D1351713

PEOPLE KISSING

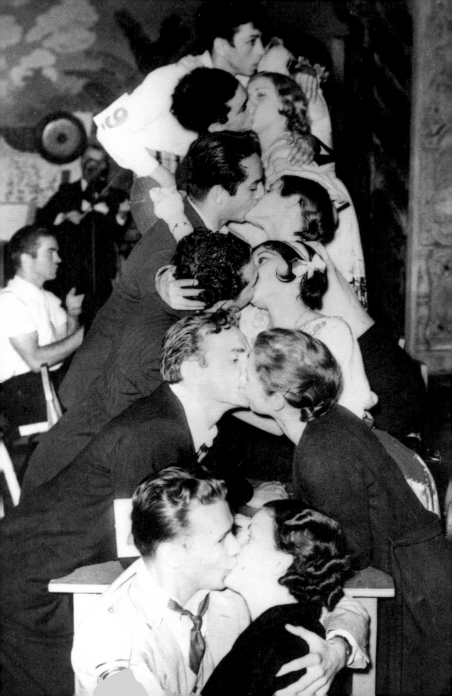

PEOPLE KISSING

A Century of Photographs

BARBARA LEVINE & PAIGE RAMEY

PRINCETON ARCHITECTURAL PRESS
NEW YORK

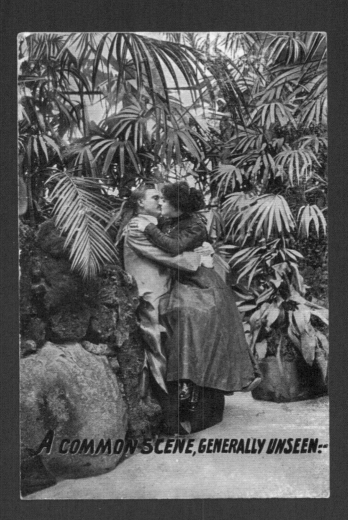

A COMMON SCENE, GENERALLY UNSEEN:-

W hile it may not be polite to stare at people kissing in public, and it's practically illegal to spy on people kissing in private, it's downright irresistible to look at people kissing in a photograph. We immediately start creating a story from the image: Who are these kissers? What is their relationship? What do they see in each other? Is it mutual? Are they kissing the way I kiss, or want to be kissed? If a picture is worth a thousand words, then a picture of people kissing can tell a thousand stories. The images collected here, spanning one hundred years, are a testament to our inherent curiosity, vicarious pleasure, occasional voyeurism, and constant delight in catching other people in a moment of connection.

Our fascination is understandable. Most human expressions of emotion are solitary acts: we cry, we smile, we furrow our brow, we scream, we chuckle. We can express these emotions solo. When we see pictures of people in an emotional state, they communicate something essential about one person at one moment in time.

Kissing, though, is a wondrous, collaborative act. It is one of the most recognizable, simple expressions in our physical vocabulary, yet because it involves two (or more!) people, a photograph of people kissing conveys not only a feeling, but an entire relationship.

What a range of emotions and dynamics are captured in a picture of a kiss! A kiss can be a friendly peck, a romantic smooch, or a lusty deep dive. It can be as tender as a mother kissing her newborn, as theatrical as a photo booth goof-off, or as false as a frenemies' selfie. A kiss can be flirtatious or funny; a kiss can be covert or unwanted. Looking at the photographs in these pages, we find kisses that are childlike or sexy; clandestine or brazen; utterly candid or staged for comedy.

Before the age of photography, kissing was a private, secular affair, and widespread images of people kissing were fairly

uncommon. The ancient Greeks occasionally painted kissing lovers (of all genders) on ceramics, and centuries-old Japanese drawings have been found depicting kissing within the intimate world of courtesans and their patrons. In the European fine-art tradition, before the rise of the camera, a mythological or Biblical kiss might come to life, but rarely was an ordinary couple kissing deemed an appropriate subject to memorialize in art.

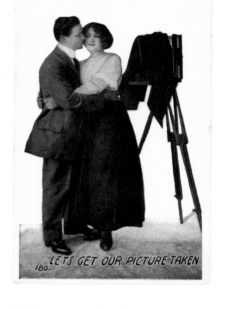

LETS GET OUR PICTURE TAKEN

It wasn't until the nineteenth century, with the advent of Victorian postcards and illustrated novels, that viewers were treated to images of everyday people like themselves engaged in one of the most common of physical interactions.

Photography changed everything: suddenly the most intimate expressions of affection could be captured, reproduced, and shared—both privately and publicly. The portrait studio became a staging area where kisses could be posed—even if the need to keep stock-still for the duration of an exposure meant that portrait kisses often came across as strangely formal.

As handheld, inexpensive film cameras proliferated in the early twentieth century, so did the variety of images of people kissing. No longer limited to a studio or a souvenir pose, couples dared to be more spontaneous or candid with their kissing—be they same-sex

couples photographed by a knowing friend or all manner of family and romantic relationships captured by a stranger. Many of the most delightful photographs in this book are from an era in popular photography when the subjects seem to be giddily enjoying a new freedom by immortalizing it with a personal camera, in a carnival photo booth, on a comic picture postcard, or with a Polaroid snapshot. In that predigital era, before every moment of a relationship could be preserved by a selfie and unlimited cloud storage, those new forms of instant photography were groundbreaking ways of capturing and preserving the spontaneous emotions of a kiss that had previously been unrecordable.

When it comes to romance, it is universally acknowledged that kissing is not only a rewarding end in itself, but a prelude to

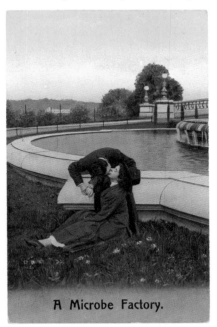

A Microbe Factory.

something more. Kissing, as the analogy goes, is just "first base." Many photographs of a kiss are laced with the innuendo of what's to follow. A lover might be tempted to add a caption or inscription that carries the idea a bit further. While remaining chaste (and safe from interstate postal regulations!), a picture of a kiss could signify far more than what appears at face value.

In a coy twist, a surprising number of early photographs come with

captions referring <wink, wink> to the supposed public health benefits of exchanging a kiss: after all, who wouldn't want to lock lips if the shared "microbes" might serve as an inoculation against disease? But especially in the often puritanical United States, these same references to "cooties" or "catching it" take on a darker shade, at least in hindsight. They betray, perhaps unintentionally, an acknowledgment that in a kiss, two bodies are interacting, with the implication that what follows might be serious, forbidden, or even dangerous. And to our sensibilities now, many of the innuendos and images seem more lecherous and inappropriate than funny or clever.

Many of these photos reveal the growing influence of the movies on snapshot photography. The first on-screen movie kiss was captured in 1896, and within a few decades, movie romances would become a pervasive, if often unconscious, template for amateur photographers—from poses that mimic the starlets or heroes celebrated in photoplay magazines to direct visual quotes from popular films. Capturing ordinary people in this cinematic vocabulary was a way to close the gap, even for just a shutter-click instant, between one's humble reality and the dreamland of the movies. In the world of photography, every woman can be a femme fatale and every man a seductive Valentino.

With lighter and less expensive film cameras like the Brownie, and later the Polaroid and Kodak Instamatic cameras, photographers became more mobile and their inquisitive eye and portable equipment gave them access to photograph people kissing on city streets, parks, beaches, and other gathering places. It is natural that when we look at a snapshot of people kissing, we tend to focus on the relationship between the photo's subjects but often forget that there was a photographer present, and thus the implication of a triangulated relationship. Who was allowed access to this intimate moment? Was it a trusted friend, an encouraging collaborator, or a voyeur? These

photos invite us to imagine not only the visible relationship but the covert one as well.

As photographs of all manner of kissing became more popular, the idea of the kiss as something strictly private began to give way, replaced by the idea that the photographed kiss can be not only a public act, but a kind of performance for the camera. Many engaging photographs in this collection document an intentional pose. It's not too much of a leap to connect the idea behind a vintage image such as "Mister Seymour Hicks and Miss Ellaline Terriss"—who "perform" their romantic engagement on a postcard to be sent out to friends and family (see pages 18–19)—with the now ubiquitous sports stadium "Kiss-Cams," where unsuspecting (or all-too-suspecting) couples find themselves on the JumboTron and are encouraged by the crowd to show their affection on-camera. There, among twenty thousand baseball or hockey fans, the couple either shyly or gamely (or mock lustfully) goes at it mouth-to-mouth, to the cheers or jeers of the crowd.

The Kiss-Cam is only the latest and most visible stage in the evolution of on-camera kissing, which, despite the occasional foray toward darker emotional territory, remains one of the most consistently upbeat, larky, and charming categories in the spectrum of vernacular photography. The photographed kisses chronicled in these pages reflect the intoxicating relationship that has evolved between humans and the camera lens. It is a relationship that started (as many romances do) a bit awkwardly, shyly, and formally but, now that a certain comfort level has been achieved, has blossomed into a full-on love affair.

BARBARA LEVINE & PAIGE RAMEY
with PETER L. STEIN

♥

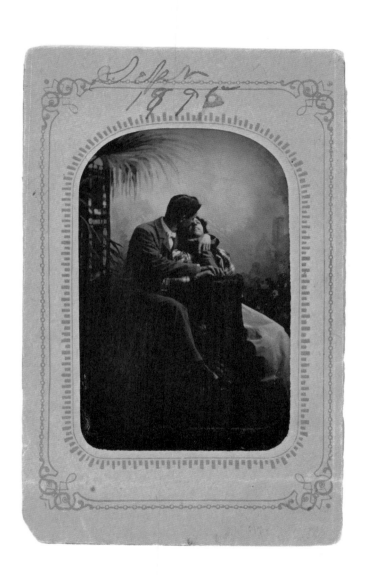

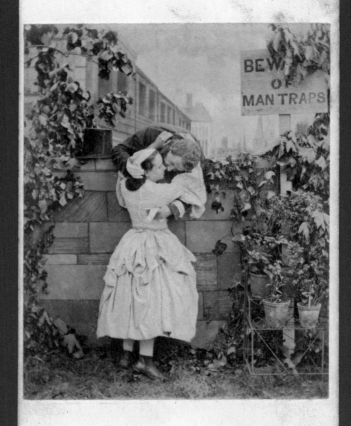

SHORT AND SWEET.

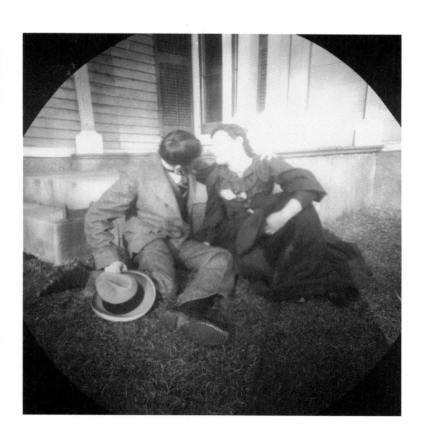

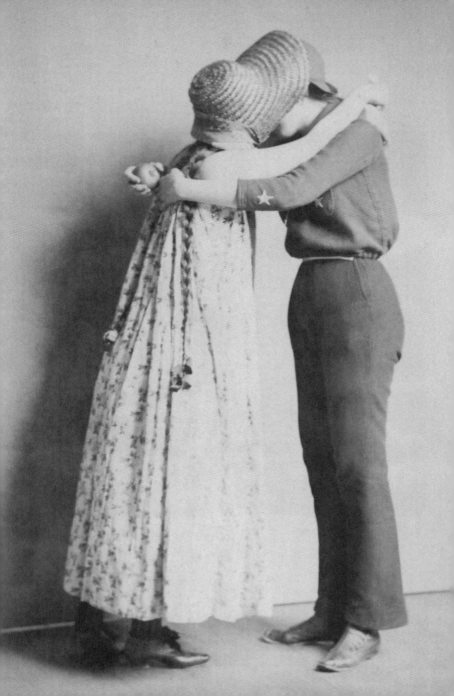

"Kiss me, and you will see how important I am."

—SYLVIA PLATH

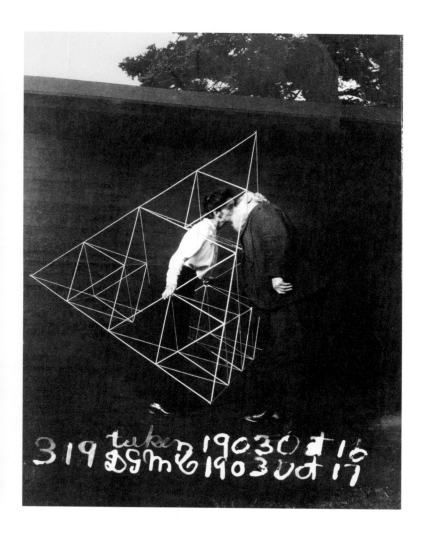

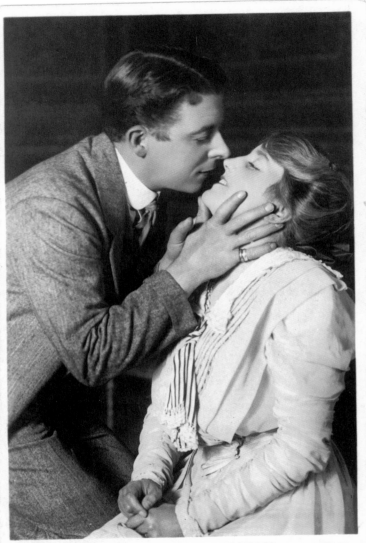

1277 B MR. SEYMOUR HICKS AND MISS ELLALINE TERRISS. ROTARY PHOTO, E.C

what a pity Seymour has such a long nose.
it is in the way **POST CARD.**
here.

For Inland Postage only, this space as well as
the back may now be used for Communication.
(Post Office Regulation.)

THE ADDRESS ONLY TO BE
WRITTEN HERE.

ROTARY PHOTOGRAPHIC SERIES.

Wednesday 25th 10/05

My dear Emilio
Very glad you like
this card, what a pity
it is not you, instead
of Seymour Hicks.
Why did you
cut that so called
photo off the p.c.? You
are very nasty to take
it, no more room to say what I
would like to. Hope to see you tomorrow
at 9 p.m. With very kind regards
yours sincerely. Katie

E. J. Babel Esq.
Stratford,
Park Road Sth,
Birkenhead

19

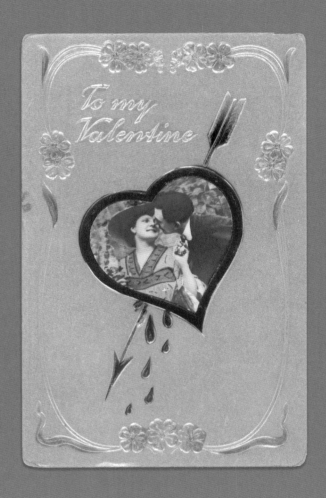

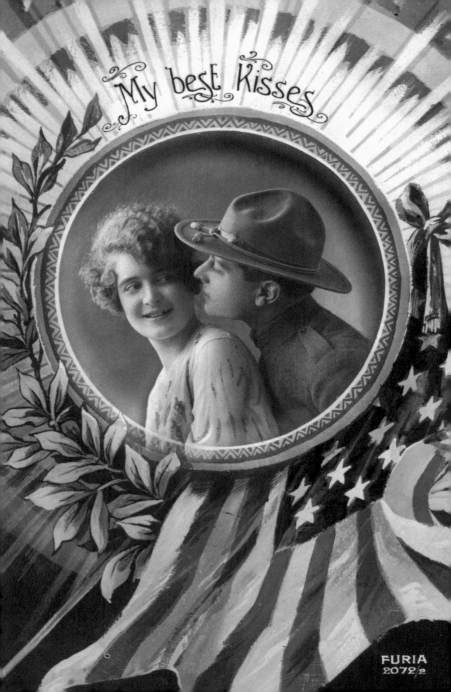

My best Kisses

FURIA
2072/2

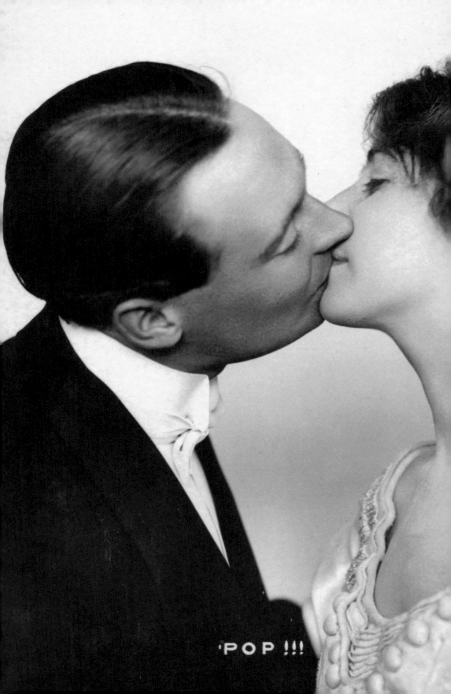

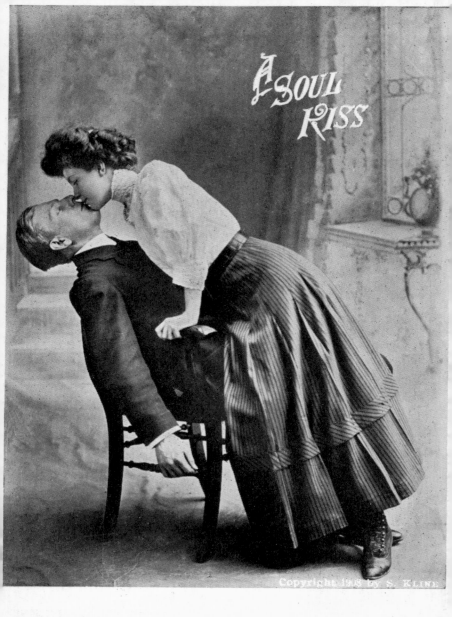

A SOUL KISS

" A Soul Kiss," will all the better feel
When you get it, and don't have to steal.

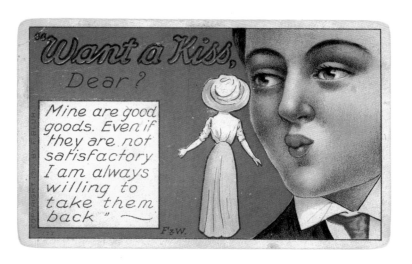

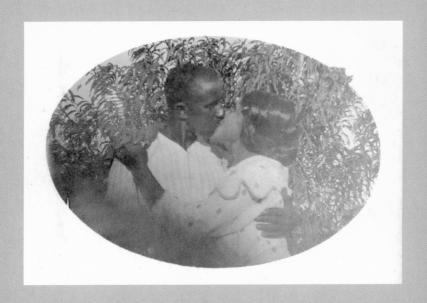

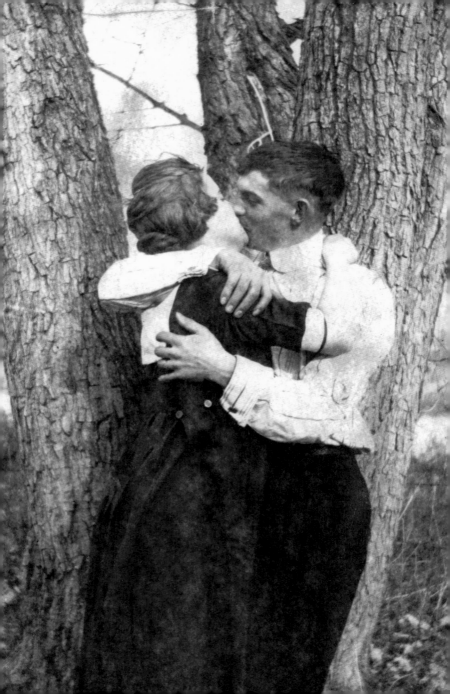

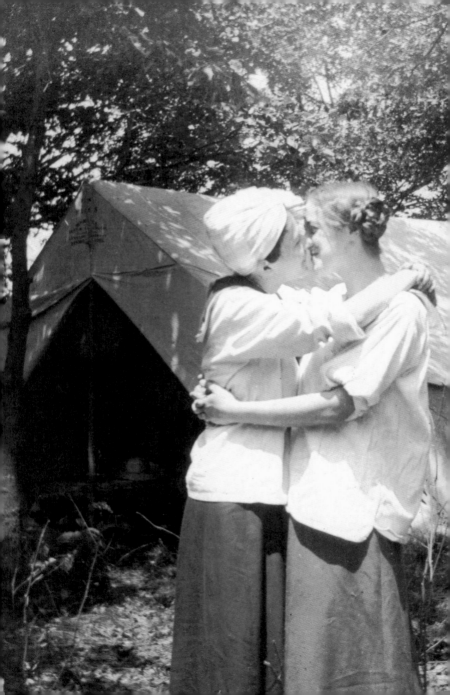

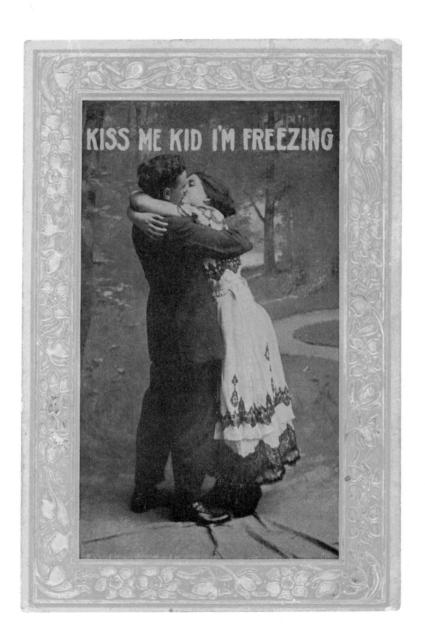

30

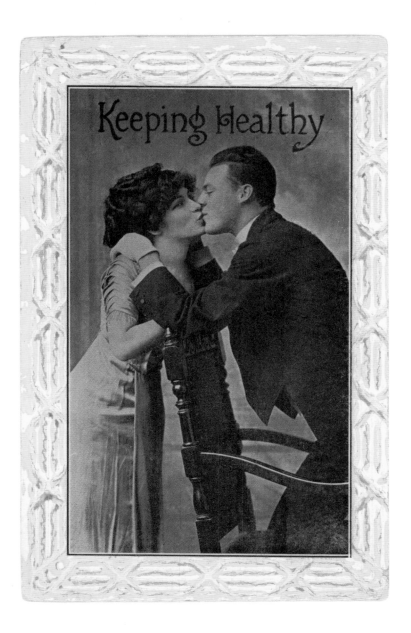

Keeping Healthy

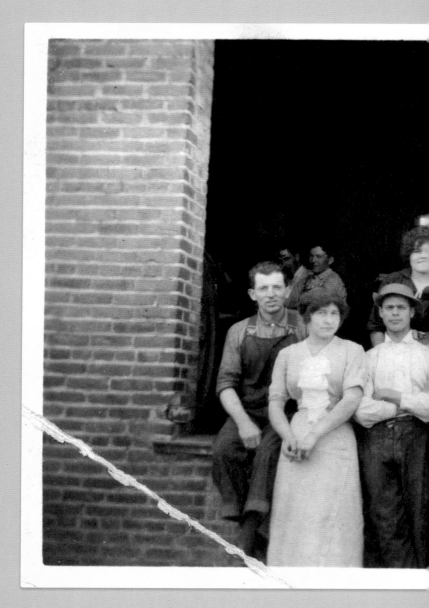

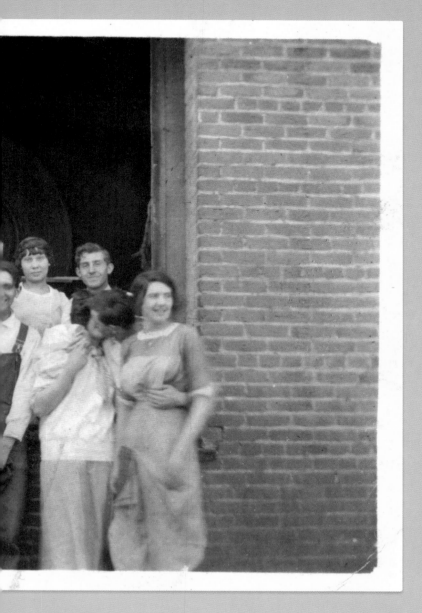

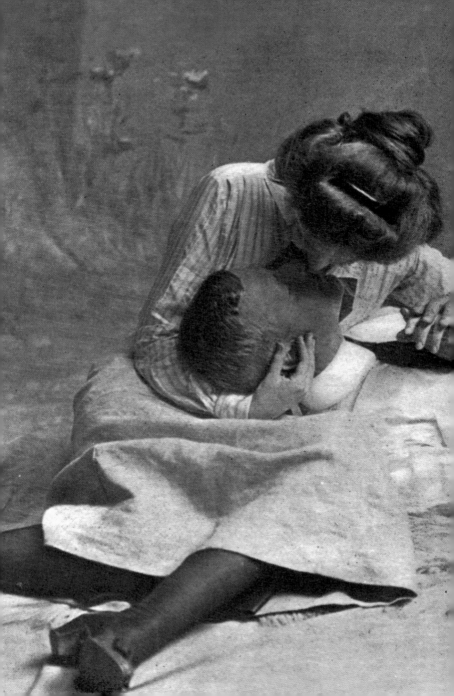

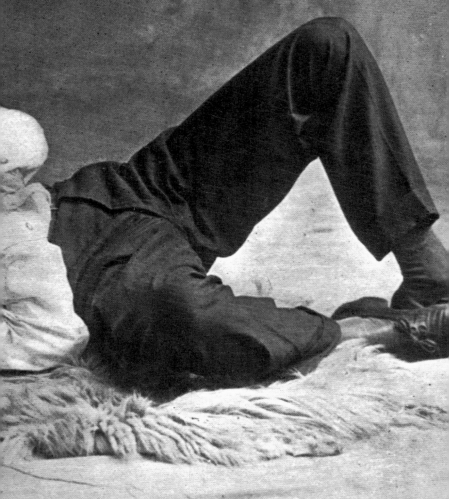

" The sound of
a kiss is not
so loud as that
of a cannon,
but its echo lasts
a deal longer. "

—OLIVER WENDELL HOLMES SR.,
The Professor at the Breakfast-Table

This is Hallie and I.
Be sure and notice
that it is _me_ .

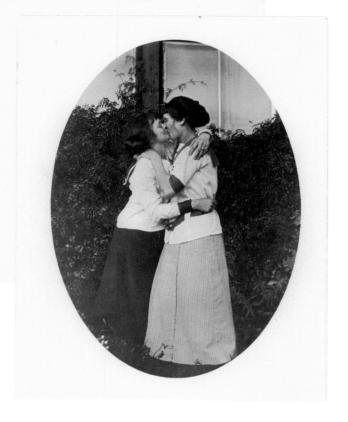

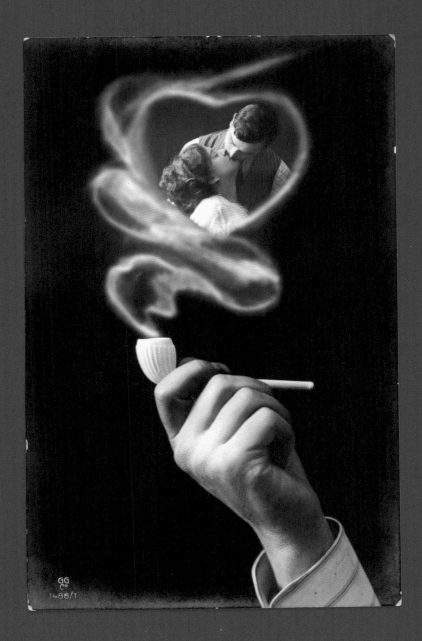

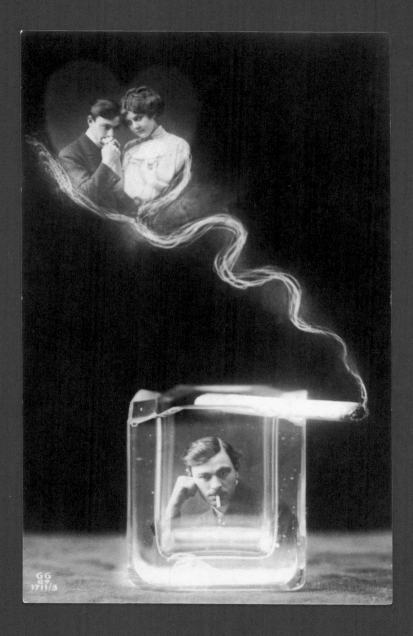

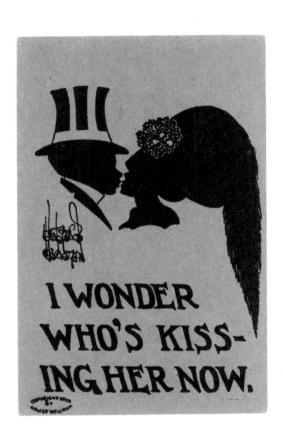

I WONDER
WHO'S KISS-
ING HER NOW.

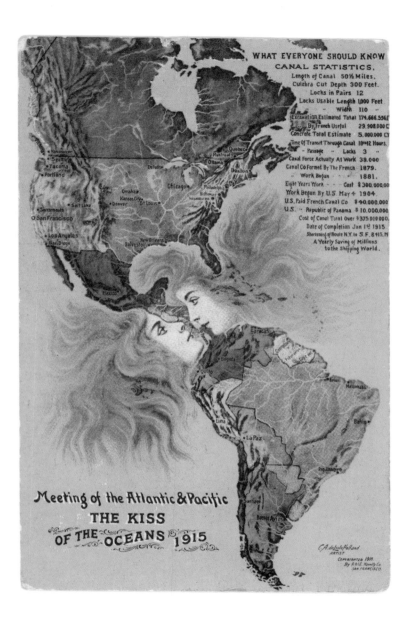

WHAT EVERYONE SHOULD KNOW
CANAL STATISTICS.

Length of Canal 50½ Miles.
Culebra Cut Depth 300 Feet.
Locks in Pairs 12
Locks Usable Length 1,000 Feet
" " Width 110 "
Excavation Estimated Total 174,666,596C
" By French Useful 29,908,000 C
Concrete Total Estimate 5,000,000 CY
Time of Transit Through Canal 10½-12 Hours.
" Passage - Locks 3
Canal Force Actually At Work 39,000
Canal Co Formed By The French 1879.
" Work Begun - - - 1881.
Eight Years Work - - - Cost $300,000,00
Work Begun By U.S. May 4 1904.
U.S. Paid French Canal Co $40,000,000
U.S. " Republic of Panama $10,000,000
Cost of Canal Total Over $375,000,000.
Date of Completion Jan 1st 1915
Shortening of Route N.Y. to S.F. 8,415 M
A Yearly Saving of Millions
to the Shipping World.

Meeting of the Atlantic & Pacific
THE KISS
OF THE OCEANS 1915

G.A. de Sotesttalland
ARTIST
COPYRIGHTED 1910.
By A.O.E. Novelty Co.
SAN FRANCISCO.

41

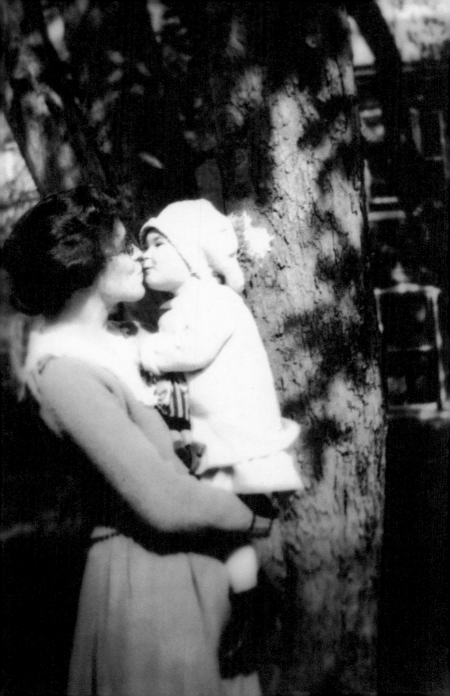

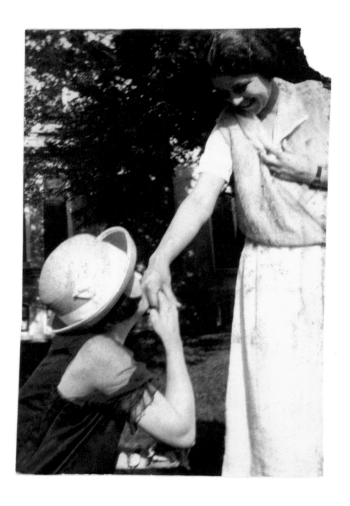

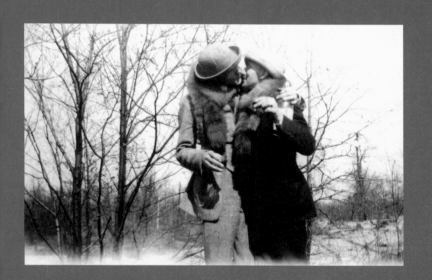

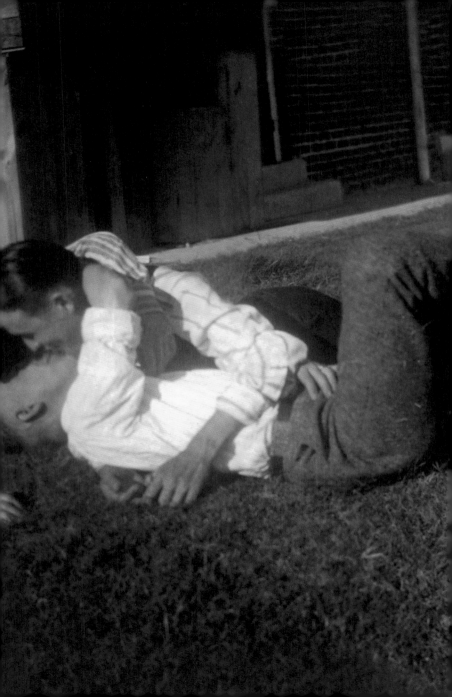

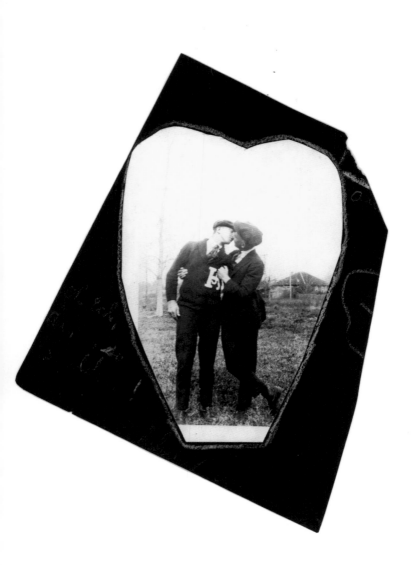

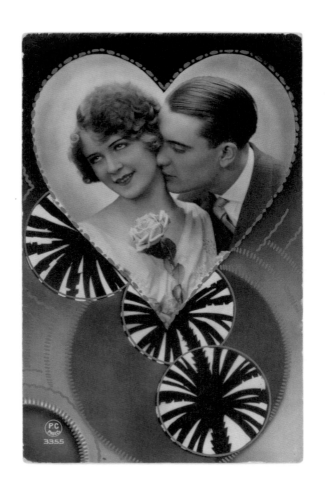

Méfiez-vous du trou de la serrure!

FURIA
621

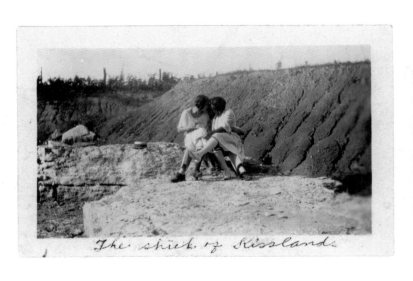

The shiek of Kissland.

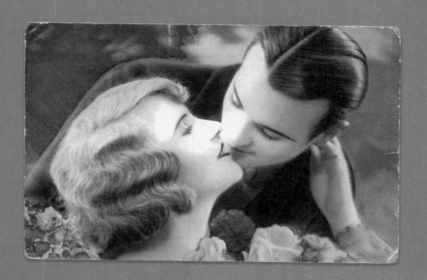

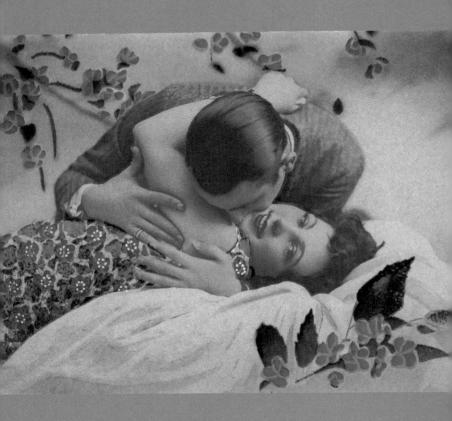

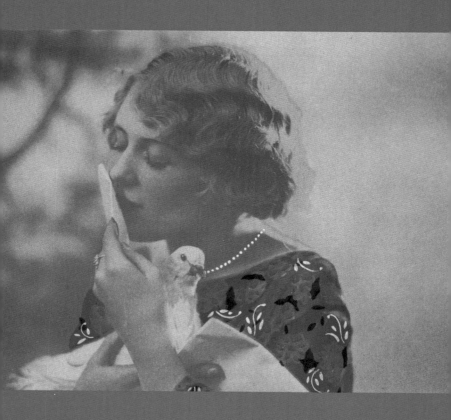

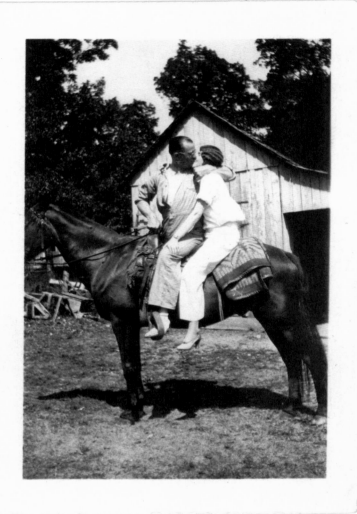

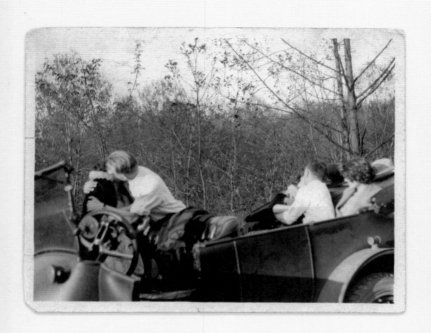

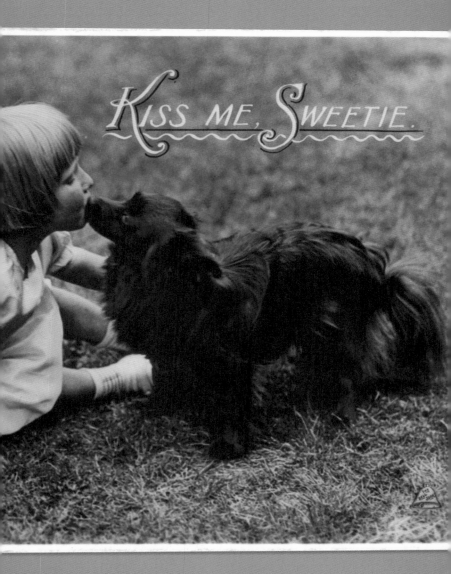

KISS ME, SWEETIE.

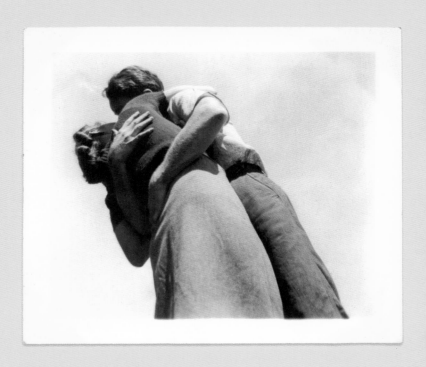

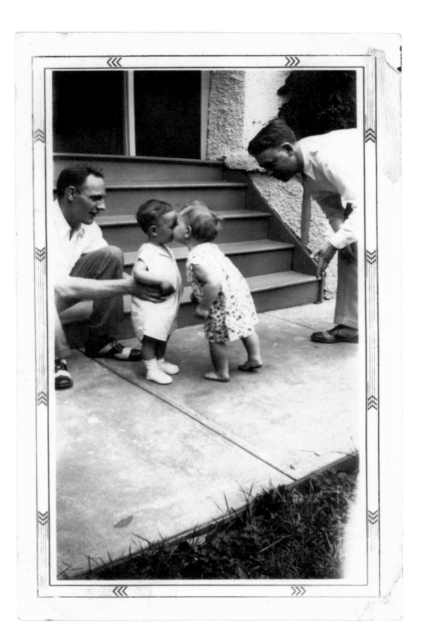

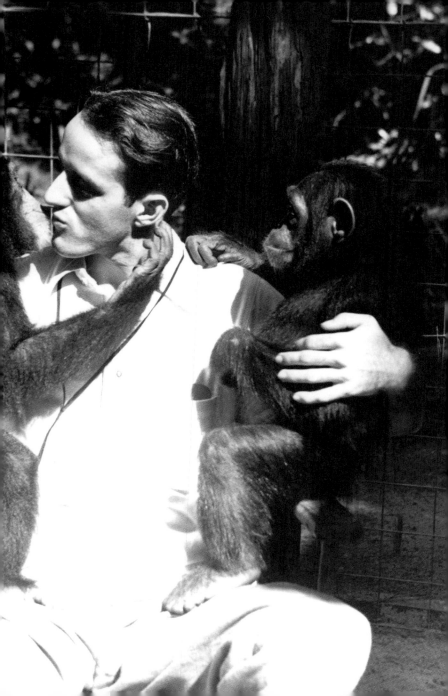

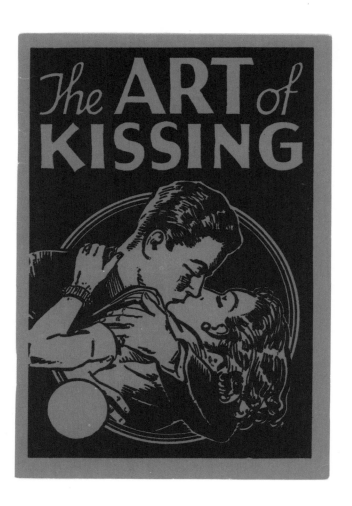

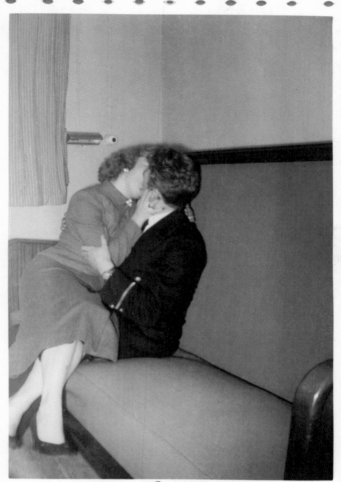

The Payoff

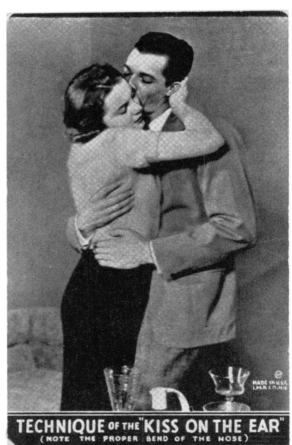

TECHNIQUE OF THE "KISS ON THE EAR"
(NOTE THE PROPER BEND OF THE NOSE)

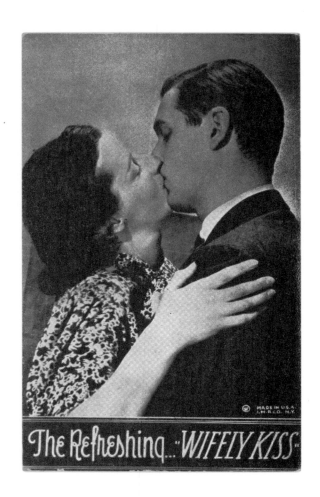

The Refreshing..."WIFELY KISS"

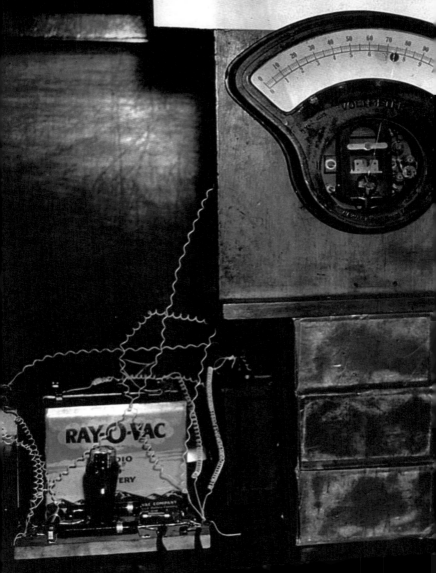

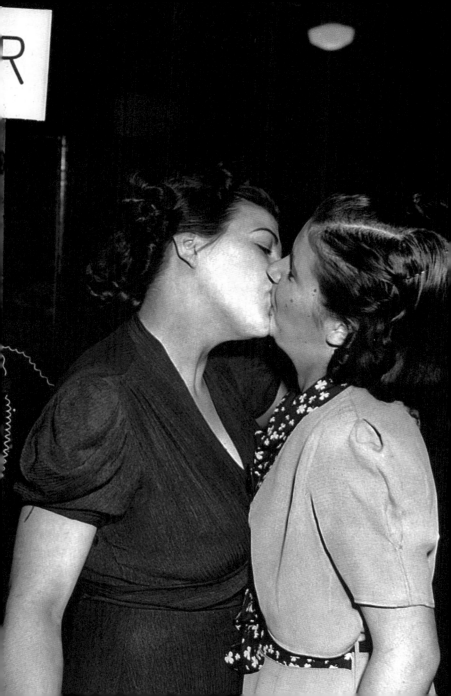

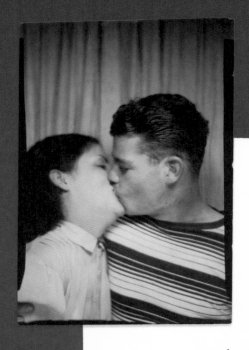

Mom & Dad
Teenagers

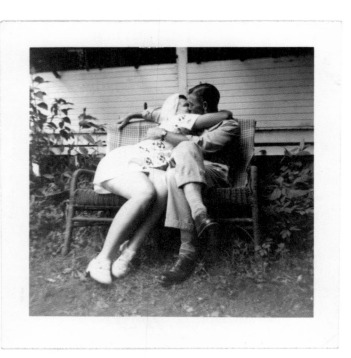

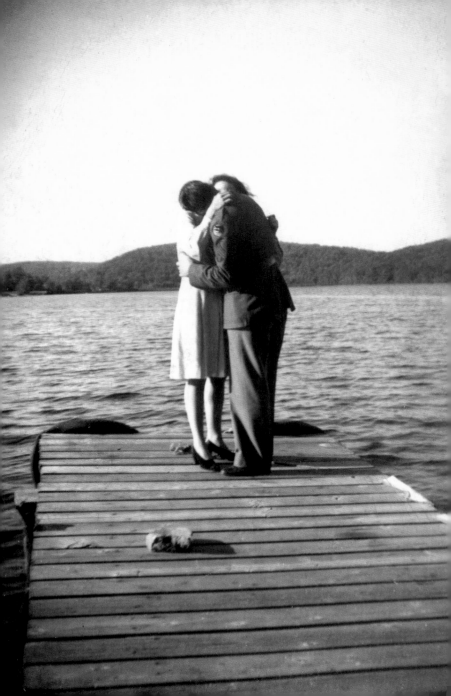

" For tho' I know he loves me, To-night my heart is sad; His kiss was not so wonderful As all the dreams I had. "

—SARA TEASDALE,
The Kiss

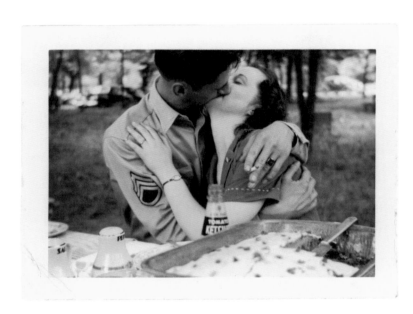

PHIL

Clarice Phil

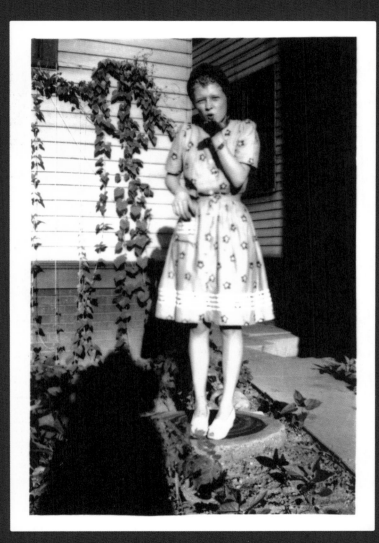

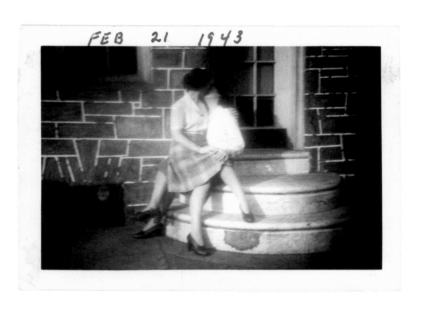

FEB 21 1943

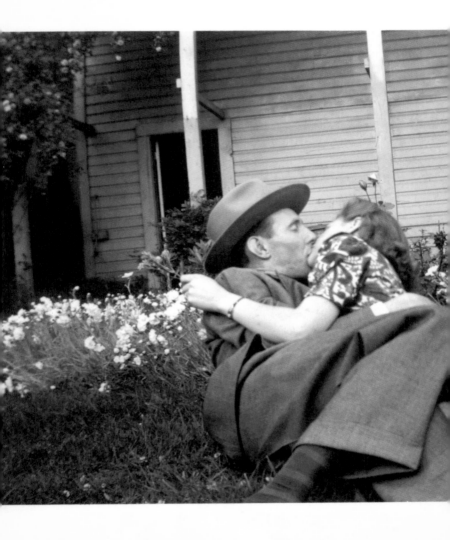

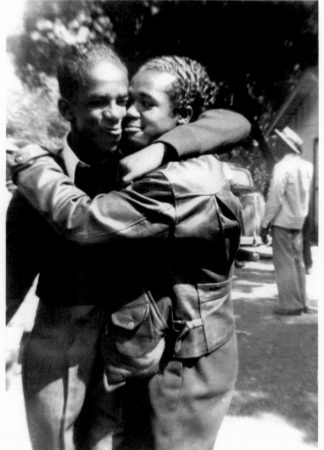

Two Fools

Calif.

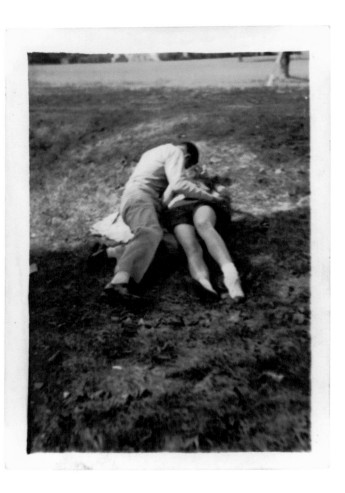

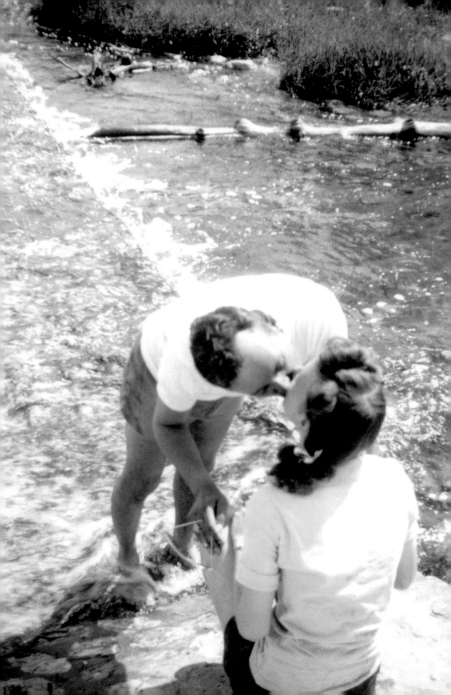

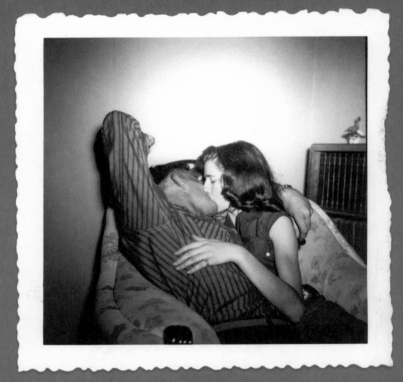

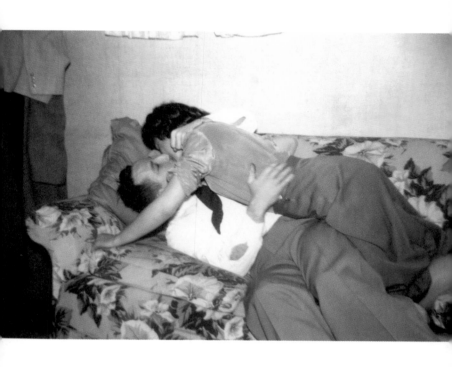

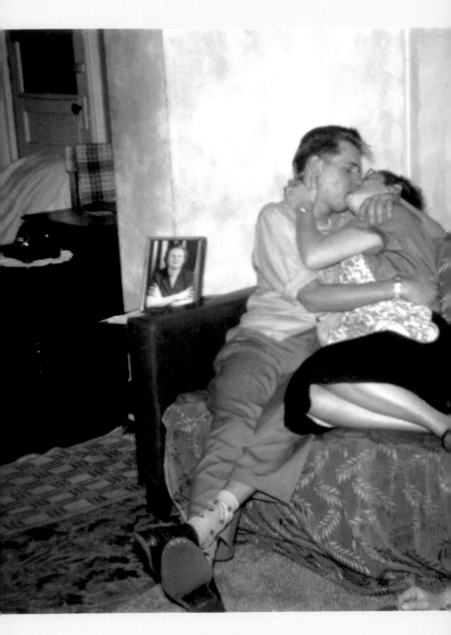

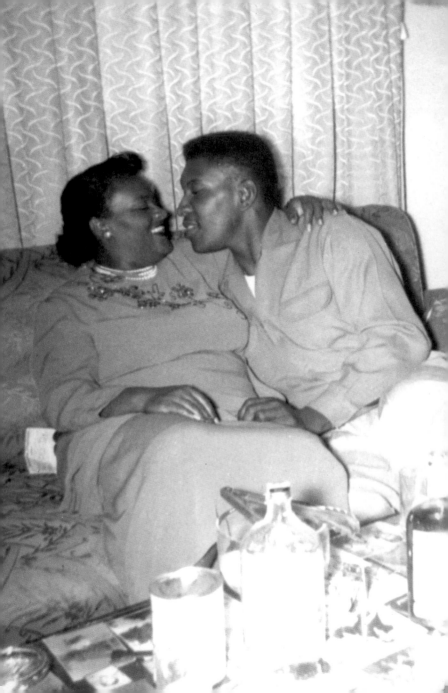

" I can't write
without a reader.
It's precisely
like a kiss—
you can't do
it alone. "

—JOHN CHEEVER

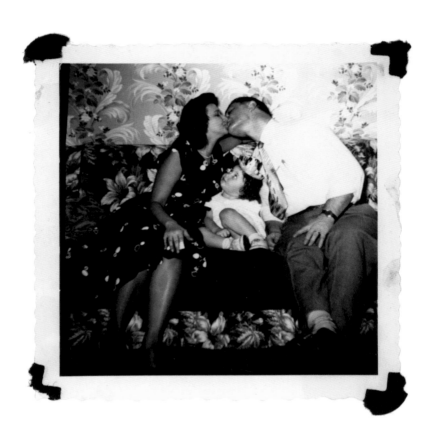

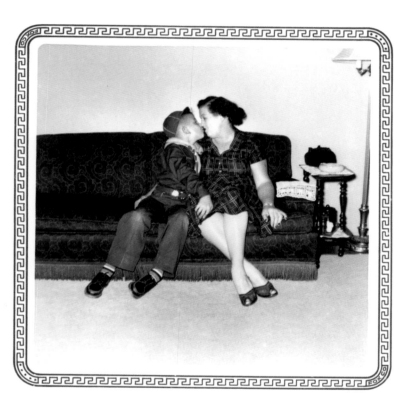

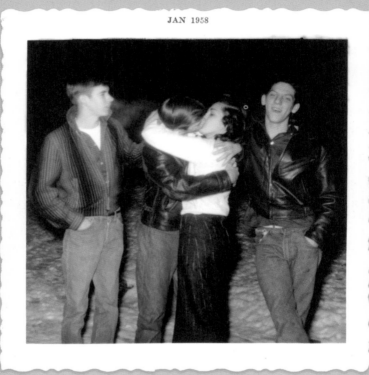

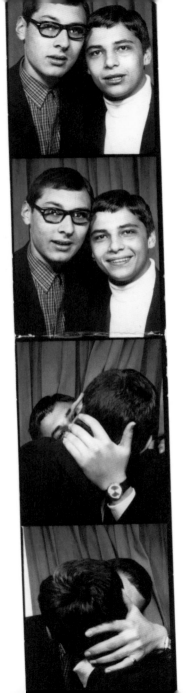

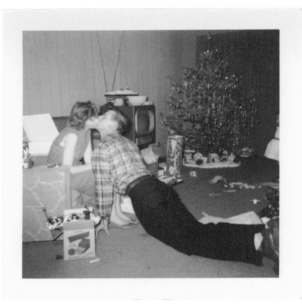

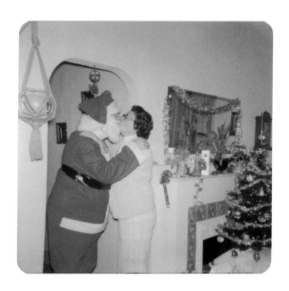

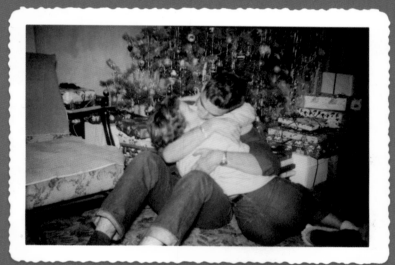

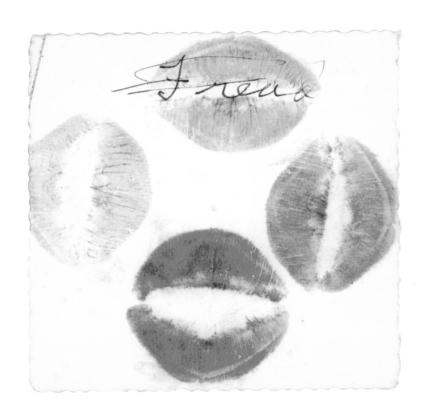

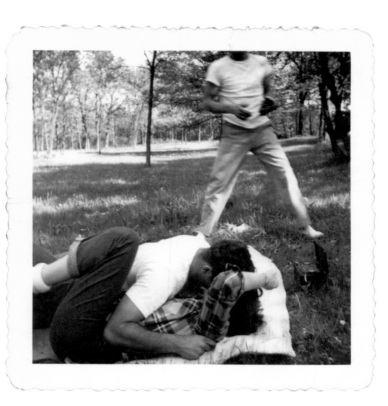

" A many Kisses
he did give:
And I return'd
the same
Which made me
willing to receive
That which
I dare not name. "

—APHRA BEHN,
The Willing Mistriss

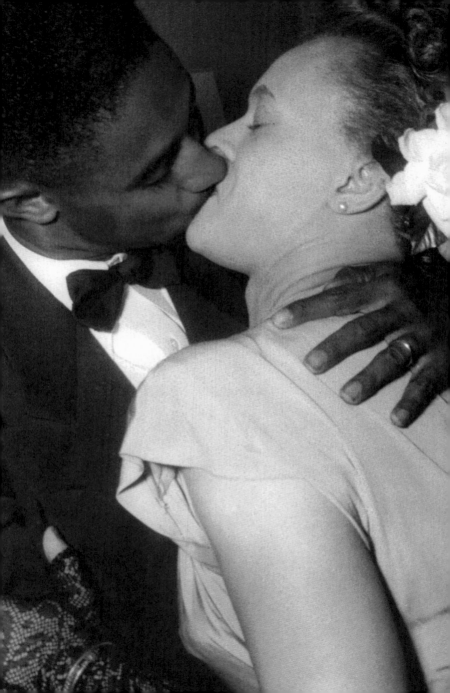

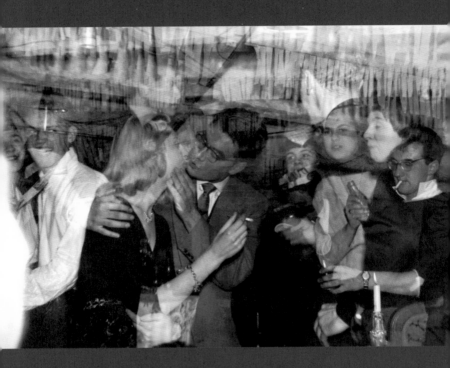

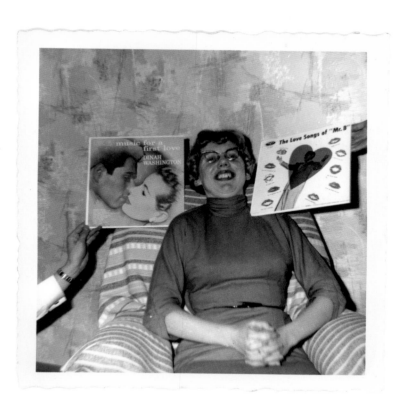

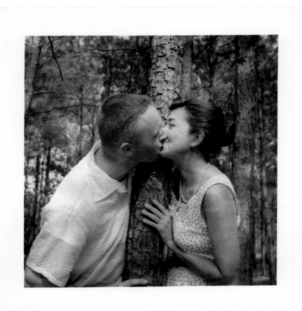

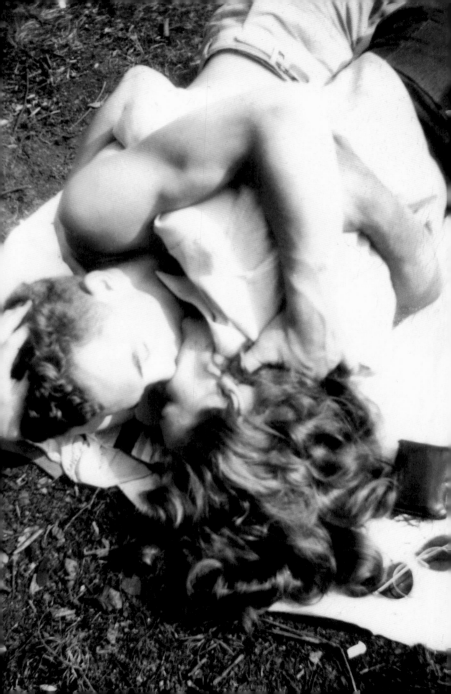

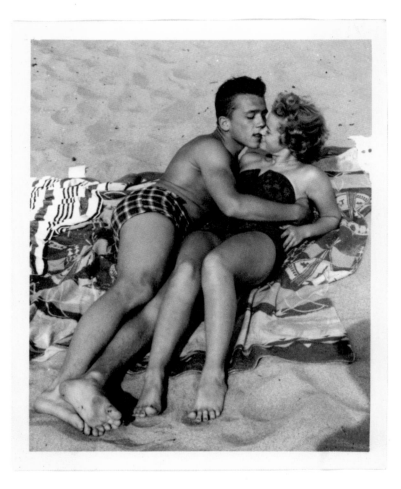

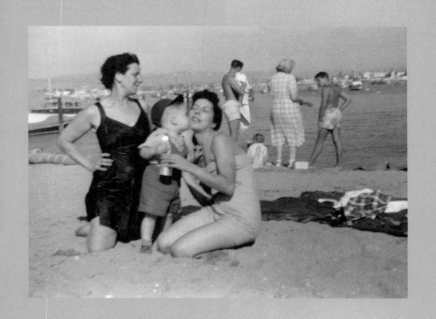

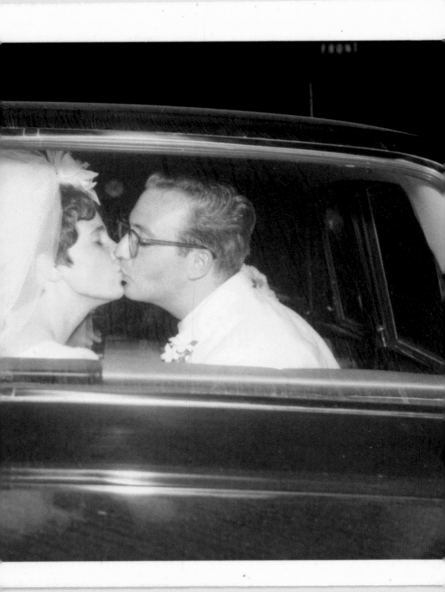

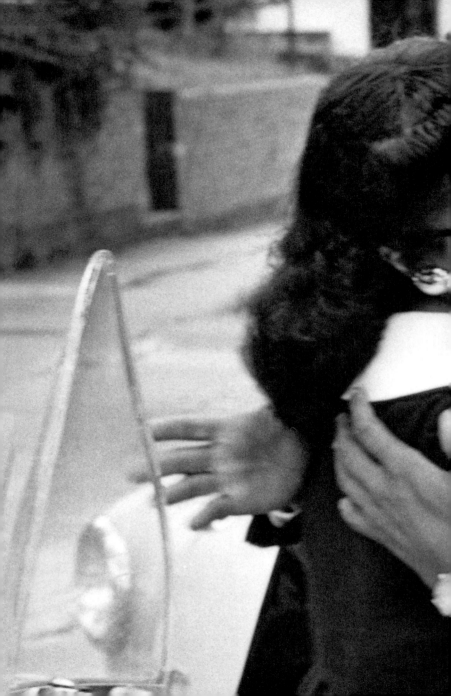

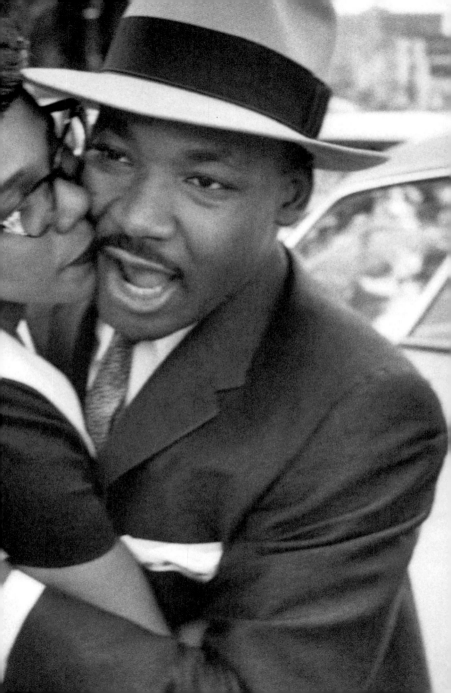

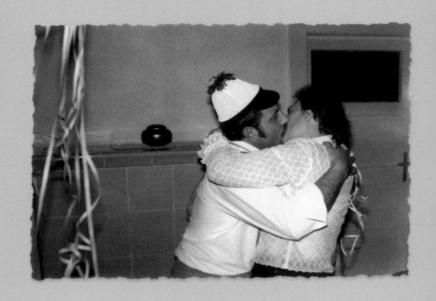

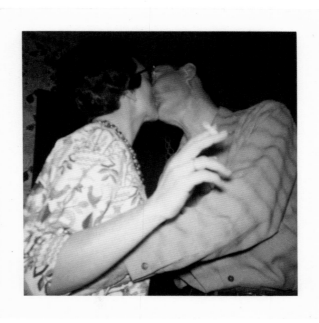

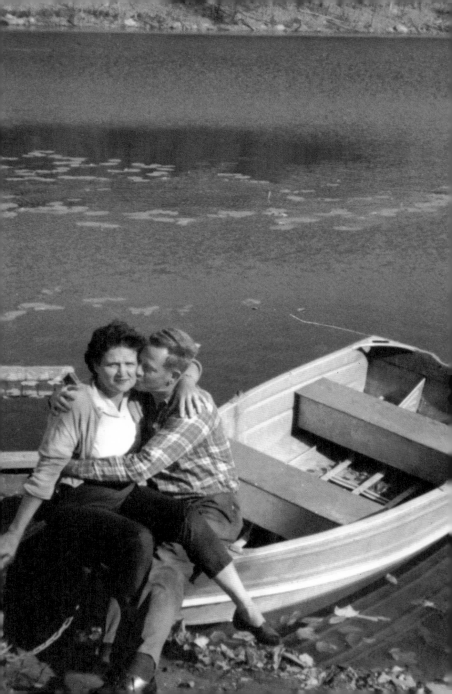

" Be plain in dress, and sober in your diet; In short, my deary, kiss me, and be quiet. "

—LADY MARY WORTLEY MONTAGU,
A Summary of Lord Lyttelton's Advice to a Lady

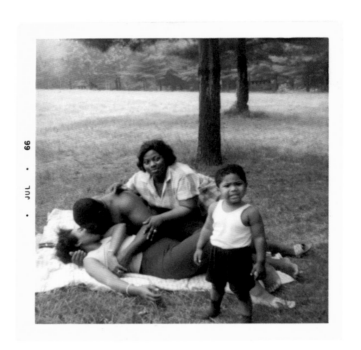

JUL · 99 ·

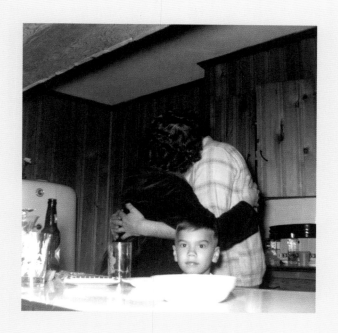

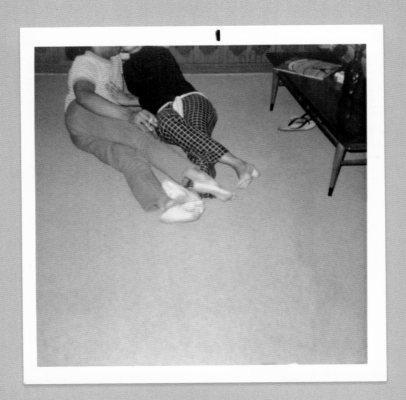

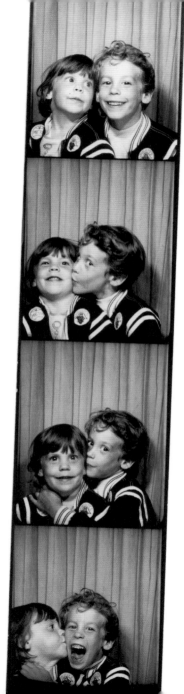

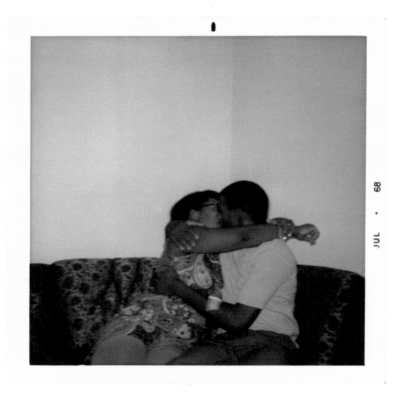

JUL · 68

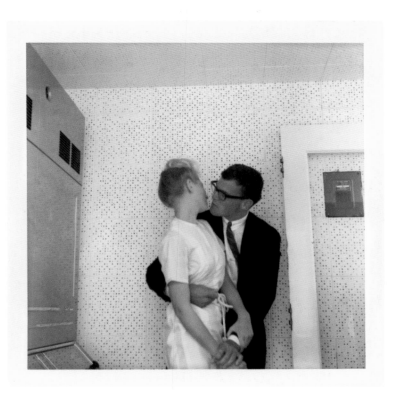

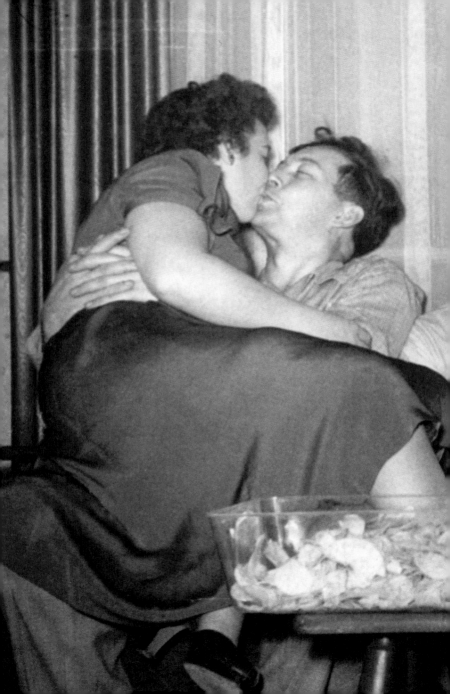

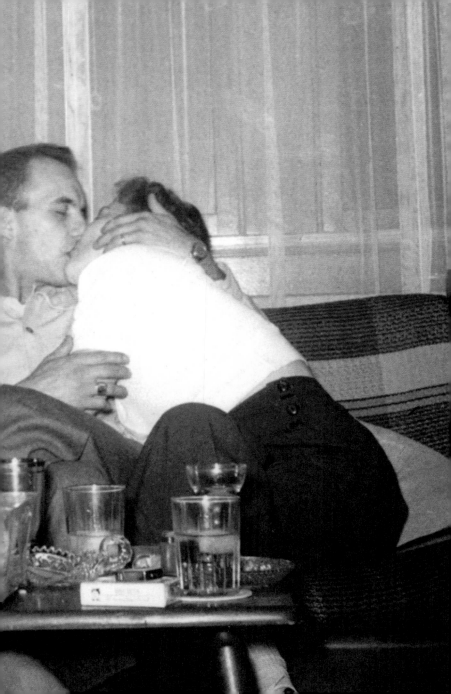

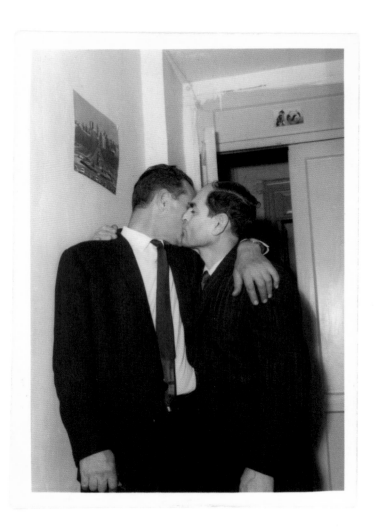

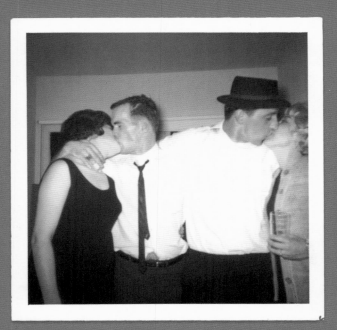

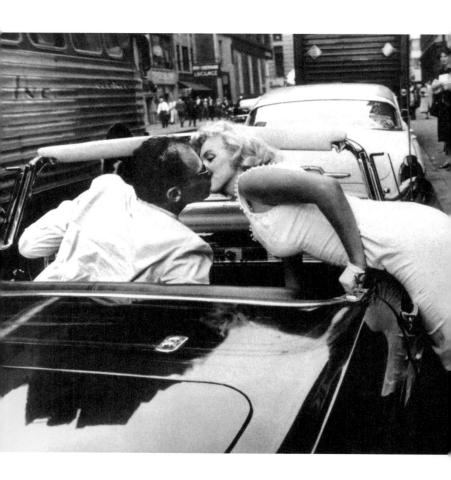

" Hollywood
is a place where
they'll pay you
a thousand dollars
for a kiss and
fifty cents
for your soul. "

—MARILYN MONROE

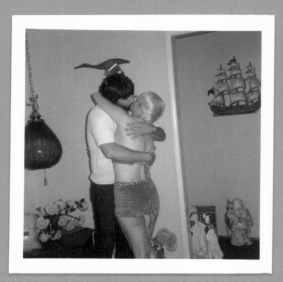

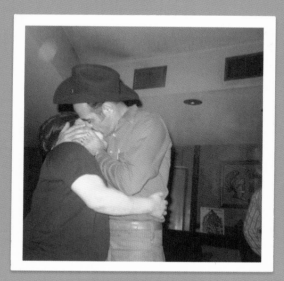

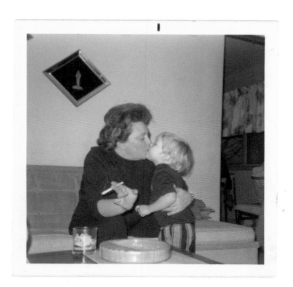

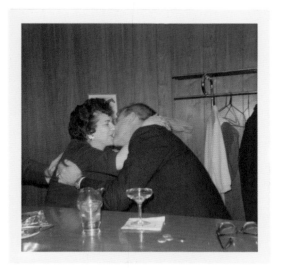

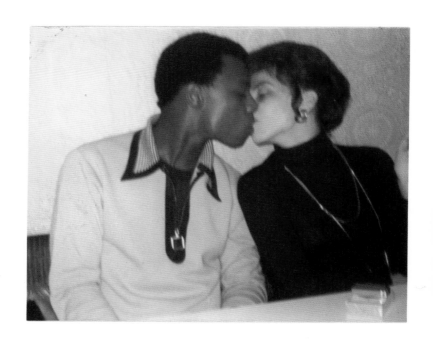

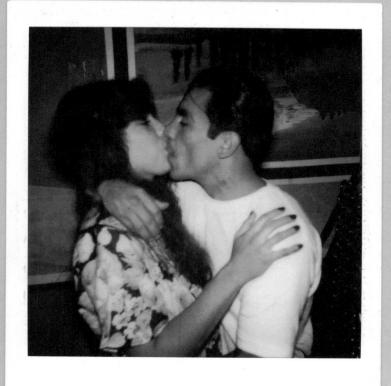

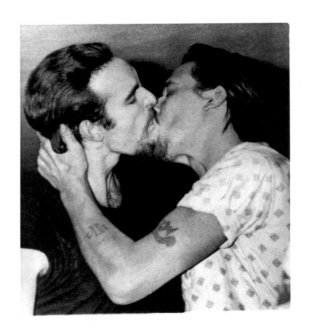

COWRIE
lesbian feminist

OCT. 73
Vol.1 no.3

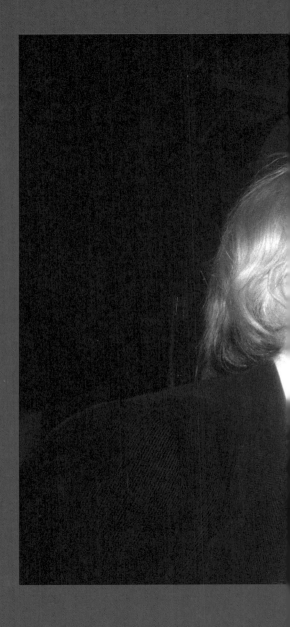

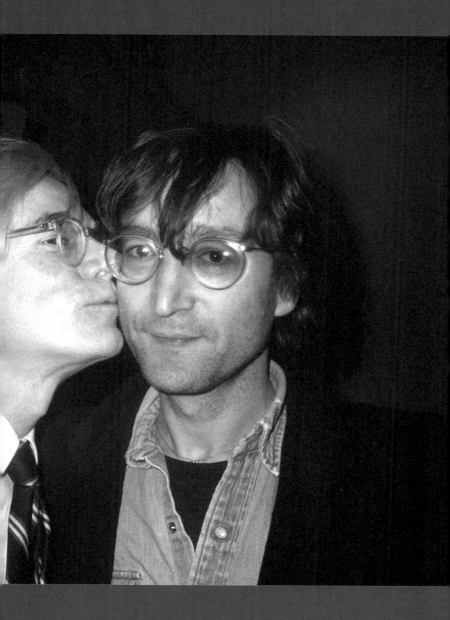

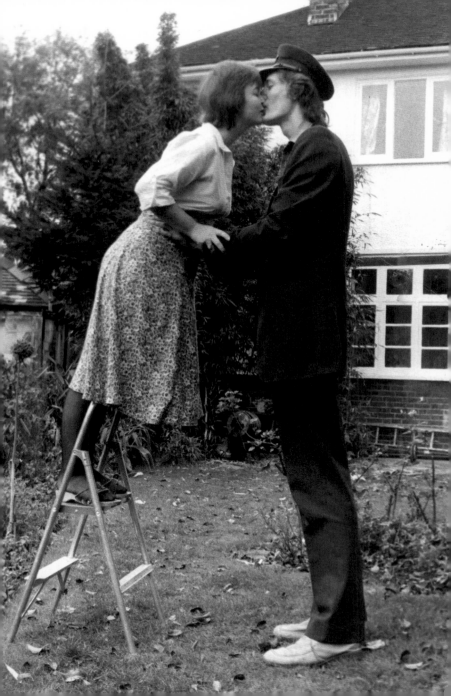

INDEX *of* IMAGES

Unless noted, photographer is unknown and
photograph is in the collection of Barbara Levine.

TERMS

AMBROTYPE: a positive photograph on glass; introduced in the 1850s.

CABINET CARD: a photograph mounted on a card measuring 4 ¼ by 6 ½ inches; used primarily for photographic portraiture after 1870.

CARTE DE VISITE: a small, thin albumen photograph mounted on a 2 ½ by 4 ¼ inch card. Introduced in 1850; abbreviated as CDV and also known as a visiting card.

REAL PHOTO POSTCARD: a card made by printing a negative onto photo paper with a preprinted postcard backing (distinguished from most postcards, which are printed using lithographic or offset printing). Sometimes called RPPCs, they came into wide use beginning in 1900.

TINTYPE: a positive photograph made on a thin sheet of metal coated with a dark lacquer or enamel; very popular in the late 1800s.

Cover and page 58: Snapshot, 1939

Front endpaper: Kiss me quick, photomontage postcard, 1907

Back endpaper: Kisses, photomontage postcard, 1907

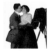

2: Kissing contest, press photo, 1937

4: "A common scene, generally unseen," photo postcard, ca. 1910

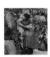

6: "Let's get our picture taken," photo postcard, ca. 1905

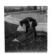
7: "A Microbe Factory," photo postcard, 1909

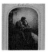
11: Tintype in paper frame, 1896

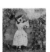
12: "Short and sweet," carte de visite, ca. 1880

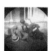
13: Albumen print, cabinet card, March 11, 1894

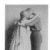
14: Women Kissing, 1890
LIBRARY OF CONGRESS
PRINTS AND PHOTOGRAPHS
DIVISION

17: Alexander Graham Bell kissing his wife, Mabel Hubbard Gardiner Bell, who is standing in a tertrahedral kite, Baddeck, Novia Scotia, 1903
LIBRARY OF CONGRESS
PRINTS AND PHOTOGRAPHS
DIVISION

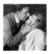
18–19: "Mr. Seymour Hicks and Miss Ellaline Terriss," real photo postcard, 1905

20: "To my Valentine," postcard with photo, ca. 1910

21: "My best Kisses," photo postcard, ca. 1910

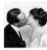
22–23: "POP!!!," real photo postcard, ca. 1907

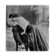
24: "A Soul Kiss," photo postcard, ca. 1910

25: "'Want a Kiss, Dear?'" postcard, 1910

26: Real photo postcard, ca. 1910

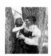
27: Snapshot, ca. 1910

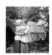
28–29: Snapshot, ca. 1910

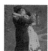 30: "Kiss me kid I'm freezing," photo postcard, ca. 1912

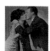 31: "Keeping Healthy," photo postcard, 1911

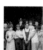 32–33: Snapshot, ca. 1910

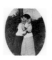 34–35: "What's in a kiss? A cause for divorce," photo postcard, ca. 1910

 37: Real photo postcard, ca. 1910

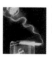 38: Real photomontage postcard, ca. 1911

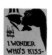 39: Real photomontage postcard, 1912

 40: "I wonder who's kissing her now," postcard, 1912

 41: "The kiss of the oceans," postcard, 1915

 43: Snapshot, 1918

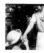 44: Snapshot, ca. 1920

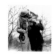 45: Snapshot, ca. 1920

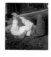 46: Snapshot, ca. 1920
COLLECTION OF
DAVID LACKEY

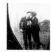 47: Houston, ca. 1920

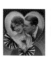 48: French tinted photo postcard, ca. 1920

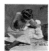 49: French tinted photo postcard, ca. 1920

50: "The shiek of Kissland," snapshot, ca. 1920

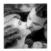

51: French tinted photo postcard, ca. 1920

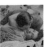

52: French tinted photo postcard, ca. 1920

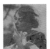

53: French tinted photo postcard, ca. 1920

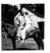

54: Snapshot, ca. 1930

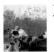

55: Snapshot, ca. 1930

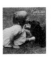

56–57: "Kiss me Sweetie," real photo postcard, 1933

59: Snapshot, ca. 1930

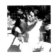

60–61: Press photo, 1939

62: *The Art of Kissing,* by Clement Wood, 1936

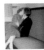

63: "The Payoff," snapshot, ca. 1945
COLLECTION OF
PETER J. COHEN

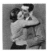

64: "Technique of the 'Kiss On The Ear,'" postcard, ca. 1940

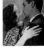

65: "The Refreshing Wifely Kiss," postcard, ca. 1940

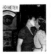

66–67: Kiss-O-Meter, 1940

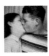

68: Photo booth, ca. 1939

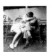

69: Snapshot, ca. 1940

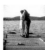 70: Snapshot, ca. 1945

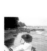 72: Snapshot, 1943

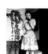 73: Clarice and Phil, ca. 1945

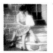 74: Snapshot, ca. 1945

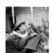 75: Snapshot, 1943

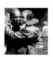 76–77: Snapshot, ca. 1945

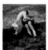 79: "Two Fools," snapshot, 1940

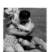 80: Snapshot, ca. 1945

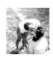 81: Snapshot, ca. 1945

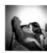 82: Snapshot, ca. 1950

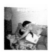 83: Snapshot, 1951

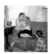 84–85: Snapshot, ca. 1950

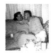 86: Snapshot, ca. 1955

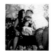 88: Snapshot, ca. 1950

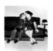 89: Snapshot, ca. 1950

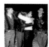 90: Snapshot, ca. 1958

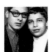 91: Photo booth, 1950

 99: Snapshot, 1957

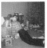 92: Kodacolor, 1956;
color snapshot, 1975

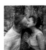 101: Snapshot, ca. 1960

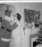

 102: Snapshot, 1956

 93: Snapshot, ca. 1955

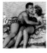 103: Snapshot, ca. 1950

94: Lipstick kisses, ca. 1950

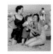 104. Snapshot, ca. 1960

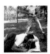 95: Snapshot, ca. 1950

 105: Snapshot, ca. 1960

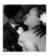 97: Snapshot, ca. 1955

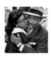 106–7: Just married, color
snapshot, 1959

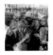 98: Double exposure
snapshot, 1957

108–9: Coretta Scott King
kisses her husband, Dr.
Martin Luther King Jr.,
Montgomery, Alabama,
late 1950s
PHOTOGRAPH BY CHARLES
MOORE / GETTY IMAGES

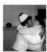 110: Snapshot, ca. 1960

 111: Color snapshot, ca. 1962

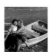 113: Color snapshot, ca. 1965

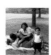 114: Color snapshot, 1966

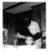 115: Snapshot, ca. 1965

 116: Color snapshot, ca. 1968

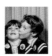 117: Photo booth, 1971

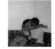 118: Color snapshot, 1968

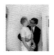 119: Color snapshot, ca. 1965

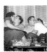 120–21: Snapshot, ca. 1960

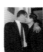 122: Snapshot, ca. 1960

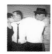 123: Color snapshot, ca. 1960

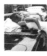 124: Marilyn Monroe leans over the door of a convertible Ford Thunderbird to kiss her husband, the playwright Arthur Miller, New York, New York, 1957
PHOTOGRAPH BY SAM SHAW / SHAW FAMILY ARCHIVES / GETTY IMAGES

 126: Color snapshot, ca. 1965; color snapshot, 1975

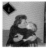

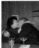

127: Color snapshot, ca. 1965; color snapshot, 1975

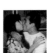

128: Color snapshot, ca. 1975

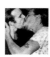

129: Polaroid photograph, ca. 1975

130: Two men reunited, 1967

131: Alix Dobkin and Liza Cowin on the cover of *Cowrie Lesbian Feminist*, 1973
PHOTOGRAPH BY ROBIN FADIN, DESIGN BY LIZA COWIN

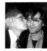

132–33: Andy Warhol kissing John Lennon, The Factory, New York City, 1978
PHOTOGRAPH BY CHRISTOPHER MAKOS, 1978, MAKOSTUDIO.COM

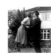

134: Mailman in England kisses his wife, press photo, 1970

PUBLISHED BY
Princeton Architectural Press
A McEvoy Group company
202 Warren Street
Hudson, New York 12534
www.papress.com

Princeton Architectural Press is a leading publisher in architecture, design,
photography, landscape, and visual culture. We create fine books and stationery
of unsurpassed quality and production values. With more than one thousand
titles published, we find design everywhere and in the most unlikely places.

EDITOR: Sara Stemen
DESIGNER: Mia Johnson

SPECIAL THANKS TO:
Paula Baver, Janet Behning, Abby Bussel, Benjamin English, Jan Cigliano
Hartman, Susan Hershberg, Kristen Hewitt, Lia Hunt, Valerie Kamen,
Jennifer Lippert, Sara McKay, Parker Menzimer, Eliana Miller, Nina Pick,
Wes Seeley, Rob Shaeffer, Marisa Tesoro, Paul Wagner, and Joseph Weston
of Princeton Architectural Press —Kevin C. Lippert, publisher

Library of Congress Cataloging-in-Publication Data
Names: Levine, Barbara, 1960- editor. | Ramey, Paige, editor.
Title: People kissing : a century of photographs /
Barbara Levine and Paige Ramey.
Description: New York : Princeton Architectural Press, [2019]
Identifiers: LCCN 2018032882 | ISBN 9781616897642 (hardcover : alk. paper)
Subjects: LCSH: Portrait photography. | Kissing in art. | Kissing--Pictorial
works. | Vernacular photography. | Levine, Barbara, 1960—Photograph
collections. | Photographs—Private collections—United States.
Classification: LCC TR680 .P4625 2019 | DDC 779/.9394—dc23
LC record available at https://lccn.loc.gov/2018032882

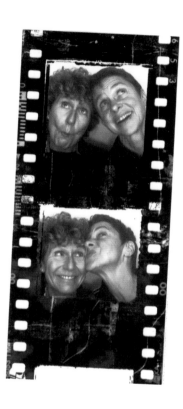

BARBARA LEVINE and PAIGE RAMEY are artists
who collect vintage found photographs and archivists who
curate. Their extensive archive, projectb.com, is dedicated
to sharing and preserving vintage vernacular photography.
Levine is the author of *People Fishing: A Century of Photographs*
(with Paige Ramey, 2018), *People Knitting: A Century of
Photographs* (2016), *Finding Frida Kahlo* (2009), *Around the
World: The Grand Tour in Photo Albums* (2007), and *Snapshot
Chronicles: Inventing the American Photo Album* (2006);
all were published by Princeton Architectural Press.

♥

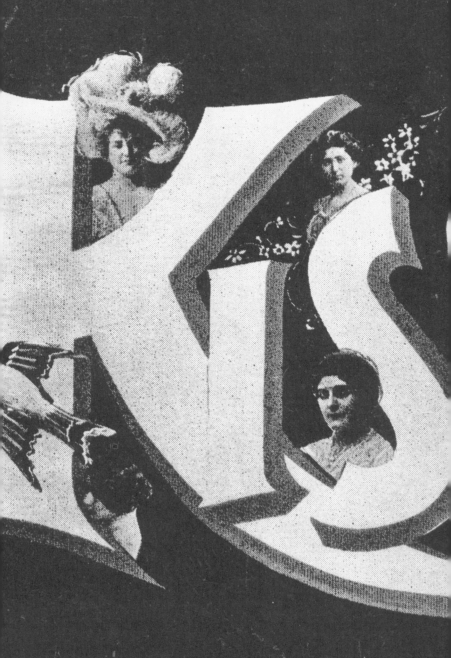

TED R.L. WELLS. 1907